CW00547145

Hill Figures of England

Maurice Askew

The Crowood Press

Preamble

From primitive cave paintings and carvings it is only a step to using hillsides as background supports for carved images, especially if you need them to be startlingly big and impressive. Although figures have been cut in the ground in many parts of the world, it is in England that hill carvings are most accepted as an art form. In a small area around Salisbury and Stonehenge these carvings abound. Here they lie on the windswept wolds, which reveal gleaming white chalk beneath the surface of smooth, sheep-cropped turf.

The story of the hill carvings of England falls roughly into three periods. The 'primitives' include the great horse of Uffington, by far the oldest and best known, dating from the time of ancient Britain; the awesome and sexually well-endowed Cerne Giant, which possibly dates from the second century AD; and the huge Wilmington man from Chaucerian days.

A jump to 1778 brings us to the first important surviving horse of the eighteenth century: the stately image of Westbury. A succession of horses followed, culminating in the Pewsey horse of 1937, created to reflect the earlier figures. Many carvings looked for their design to the works of a multitude of painters, such as George Stubbs, who specialized in horse subjects. Sometimes they were created as part of a growing interest in monuments and landscaped follies. Other hill figures were cut to commemorate special events: a battle victory, a coronation or a jubilee.

To conclude the story: an assortment of 'moderns' seemingly reflect the restless and diverse activities of the modern era. The lion at Whipsnade Wild Animal Park, a New Zealand kiwi just north of Salisbury and a collection of military badges at Fovant were all created in the first half of the twentieth century. In addition to the two giants, and excepting a few crosses and other miscellaneous abstract shapes, these are the only non-equine subjects of any importance to have survived.

The technique of cutting a hill figure is simplicity itself. The fundamental requirement is a hill that has good visibility from a distance and is fairly accessible. Ideally there should be chalk beneath the top soil, although this has not been the case with a few figures cut in the Midlands and North of England, and in Scotland.

An outline of the intended carving is marked out on the hill using poles or flags, often directed from a distance through a megaphone. Perspective should be allowed for so that the figure does not appear bottom heavy, although in a few cases this was not done and the horses have finished up with tiny heads and big feet. The turf is cut away, sometimes up to 2ft (0.5m) in depth. If the top layers of chalk are dirty, then new, clean chalk is quarried and packed on top. Today cement and white paint may be mixed in to supplement the chalk.

To keep them in good condition hill figures need to be cleaned every seven to ten years. In the past such work was often accompanied by public holidays. Fairs, sports and maypole dancing were invariably part of the celebrations. Scouring (cleaning) these days is still time-consuming and expensive. Many cuttings have been reinforced with brick or concrete edgings and in a few cases drainage pipes have been laid to prevent the dragging out of chalk at the base of the figures. Maintenance in the past usually fell to the landowner but is now generally the responsibility of English Heritage, local authorities or preservation trusts. In the case of a few hill carvings care is lovingly bestowed by local enthusiasts.

This book is one man's record of these most important hillside images. It is not an archaeological survey

nor an in-depth analysis, but one individual's reaction to marks dug into our landscape. It records an interest begun when, as a Worcestershire lad in the 1930s, I gazed at a huge, gentle-looking white lion apparently strolling along a Dunstable Downs hillside – the newly cut Whipsnade emblem.

With the war years intervening, it was not until 1954 that an article by Eric St John Brooks, 'Figures in the Chalk', in *The Saturday Book*, No.14, once more aroused my interest in this most eye-catching and enigmatic art. In more recent years still, reading the books and articles by Morris Marples, Kate Bergamer, Paul Newman and others gave me the knowledge necessary to delve into the whys and wherefores of it. Visits to England from my home in New Zealand enabled me to accumulate sketches, paintings and on-the-spot information.

Texts and the descriptions of the individual figures are mine. So are any major faults. Much of the information has been culled from authoritative sources. Much, too, was gathered from personal contact with people directly involved with the upkeep of many of the carvings and from correspondence with others. A few sources landed me with conflicting or confusing material, but I now accept that this goes with white figure territory and with the passing show of time.

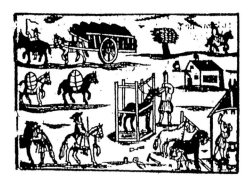

The Horse at Work (woodcut, printed by John Beale and Robert Bird, London, 1636)

Cutting or scouring of a white horse in the eighteenth century, by Richard Doyle, in T Hughes, *The Scouring of the White Horse* (1889 edn)

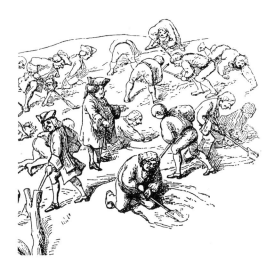

The owld White Horse wants zettin to rights,
And the Squire hav promised good cheer,
Zo we'll gee un a scrape to kip un in zhape,
And a'll last for many a year.

A was made a lang lang time ago
Wi a good dale o' labour and pains,
By King Alferd the Great when he spwiled their consate
And caddled thay wosbirds the Danes.

The Bleawin Stwun in days gone by
Wur King Alferd's bugle harn,
And the tharnin tree you med plainly zee
As is called King Alferd's tharn.

There'll be backsword play, and climmin the powl,
And a race for a peg, and a cheese,
And us thenks as hisn's a dummull zowl
As dwont care for zich spwoorts as theze.

Notes
caddled: worried; wosbirds: birds of woe; Bleawin Stwun: a local stone with a hole through it; dummell: stupid

A ballad in the Berkshire dialect sung during a scouring, recorded by T Hughes, (1889)

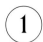

Uffington

Location: Berkshire/Oxfordshire
Landranger Series No.174;
OS Grid ref: SU867305

Date: between 1400 and 600BC
Dimensions: length 360ft (109m);
height 90ft (27m)

The earliest of the great white horses lies above the village of Uffington on a scarp of the Berkshire Downs, to which it gives the name Vale of the White Horse. The figure itself may be seen from the B4507 Swindon to Wantage Road, but it is even better from the railway running about 2 miles (3km) away from it between Swindon and Didcot. Best of all, it should be seen from the air, spread out in all its power and mystery. It may be reached by way of a longish track from a large car park or by a shorter trail from another car park intended for disabled and elderly people.

Near to the horse lie ancient earthworks known as Uffington Castle and a flat-topped mound called Dragon Hill. From the former are magnificent views towards Wiltshire, Oxfordshire and Gloucestershire. Iron Age coins found near the site carry images of prancing horses similar in form to that of the Uffington carved horse.

Many theories have been advanced respecting the figure's origins. The most recent surveys by the Oxford Archaeological Research Unit indicate that it was made during the Late Bronze Age, possibly the horse totem of a local tribe. The earliest written mention of it is in a document held at Abingdon Abbey and written in the time of Henry II (1154–89).

During Anglo-Saxon years it seems to have been accepted as a pagan symbol, but this later gave way to a Christian adaptation linking it to the story of St George and the dragon. Dragon Hill takes its name from a British chieftain Uther Pendragon, father of the legendary King Arthur.

During the eighteenth and the early nineteenth century the figure was scoured frequently, providing opportunities for celebrations and merry-making happily described in Thomas Hughes' novel *The Scouring of the White Horse*. According to reports, however, by 1880 it had fallen sadly into disrepair and it was not until 1892 that it was once more carefully restored. Since then it has been kept in good condition with the chalk cut down to 3ft (1m) in depth.

The Uffington horse stands on National Trust land and is cared for by English Heritage. The Ridgeway Path, which passes close to it, is a designated National Trail. At an estimated 5,000 years of age it is one of the oldest roads in the world.

In Uffington village is Tom Brown's School Museum, devoted to the life and times of Thomas Hughes who lived there in the nineteenth century. It is open on Saturdays and Sundays only, from 2:00 to 5:00 pm, from Easter to October.

Illustration (detail) by Richard Doyle, from T Hughes, *The Scouring of the White Horse* (1st edn, 1857)

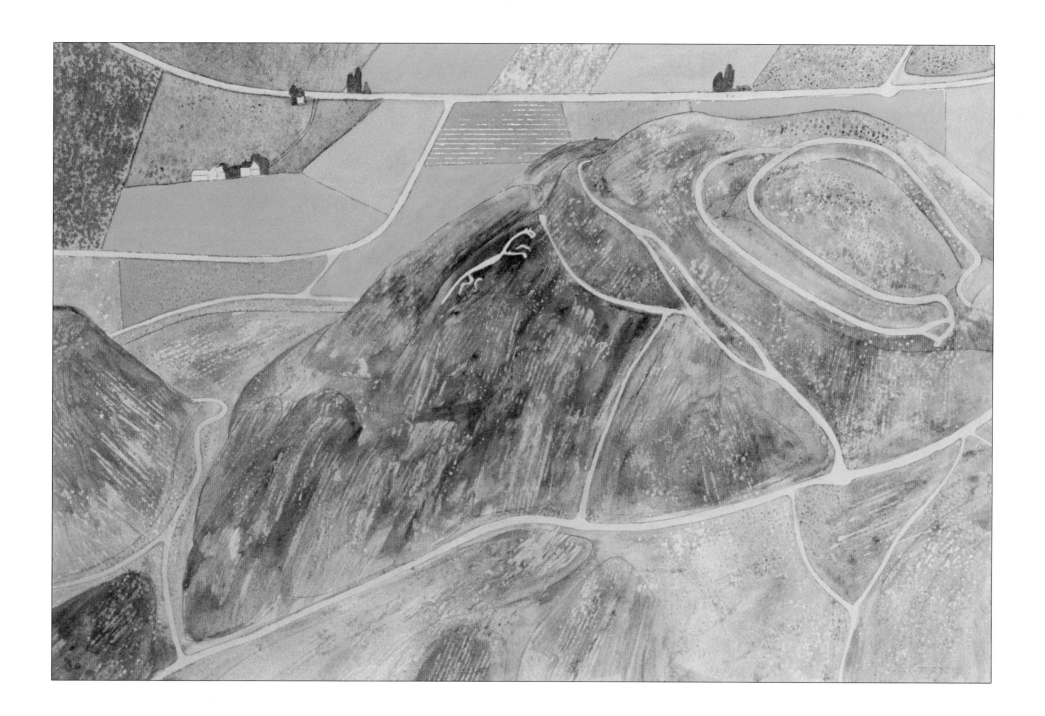

Cerne Giant

Location: Dorset
Landranger Series No.194;
OS Grid ref: ST665017

Date: between the second and
the seventeenth century
Dimensions: height 180ft (55m);
width 160ft (48m)

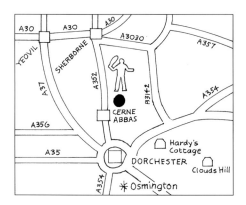

Cut on Giant Hill just north of Cerne Abbas, the figure known as the Cerne Giant may be seen clearly from the A352 road. There is a convenient parking area nearby and walking tracks lead up to the carving.

There are many conflicting theories on the purpose and time of its creation. The glaringly sexual nature of the figure suggests an association with fertility rites which may locate the giant in a pre-Christian era. Stories abound, too, of past rites, emulating those of Stonehenge, placing the figure's creation in pagan days. The aggressive stance may suggest that it was a tribal totem from the days of early Britain. There are suggestions, too, that the giant represents the Celtic huntsman Herne.

It stretches the imagination, however, to date it so far back and it is only when we come to the second century AD that we may be getting closer to the years of the giant's birth. The rather crude stance suggests a Romano-British aspect that would have been prevalent at that period. The vicious and hated Roman Emperor Commodus (AD161–92), who had renamed himself Hercules Romanus, was the nominal ruler of Britain at this time and was often portrayed brandishing a club.

Many present-day thinkers support a still later date for the giant's carving. In spite of its huge size and appearance there are no extant written reports about the giant before a note of 1694 in the Cerne parish register telling us that an 'account of three shillings was paid for the recutting of giant'. The next mention is a report in the Revd John Hutchin's *Guide to Dorset* of 1751.

Another theory suggests that Denzil Holles, owner of the land during the Civil War (1644–60) and a Parliamentarian who had fallen out with Cromwell, ordered that a naked man with a club be cut as an effigy

of his leader. Perhaps, however, the giant was simply created as a fashionable hillside folly.

For further conjectures the reader is referred to Morris Marple's extensive writings on the origins and stories of the Cerne man.

The land and the figure were presented to the National Trust in 1920 by the son of the eminent archaeologist General Pitt-Rivers and later endowed by Sir Henry Hoare of Stourhead, who provided for the permanent upkeep of the giant.

Measurements of the Cerne Giant, from *The Gentleman's Magazine*, 1764

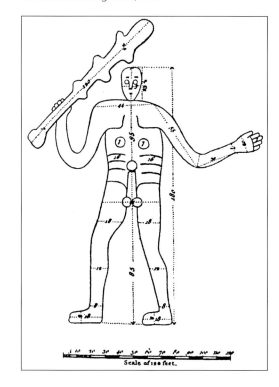

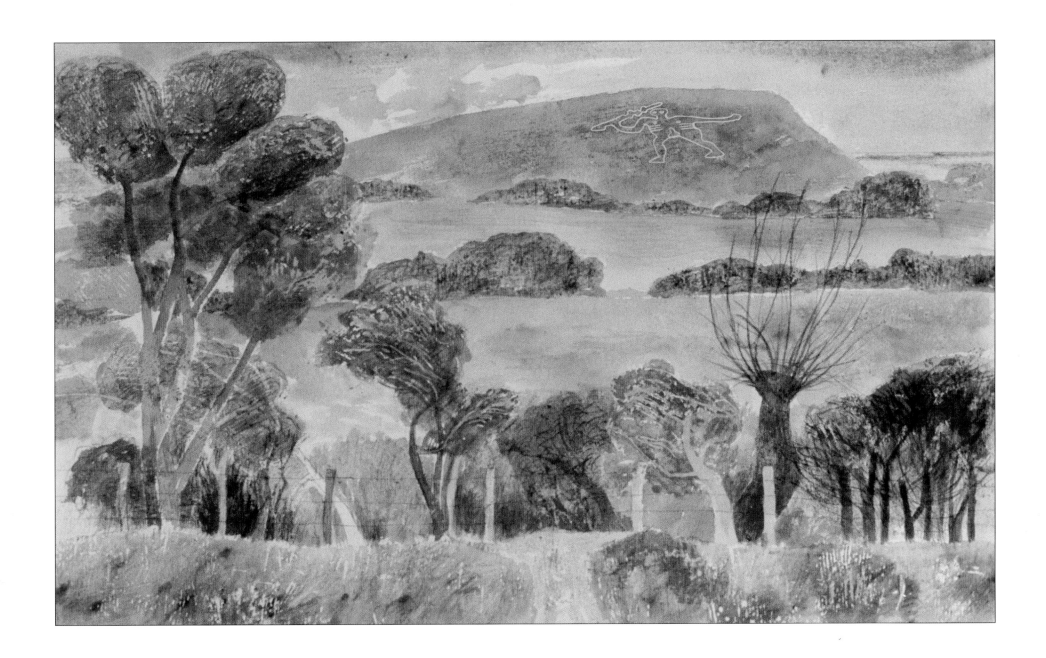

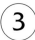

Long Man of Wilmington

Location: Sussex
Landranger Series No.199;
OS Grid ref: TQ545035

Date: fourteenth century (?)
Dimensions: height 235ft (74m);
width 200ft (60m)

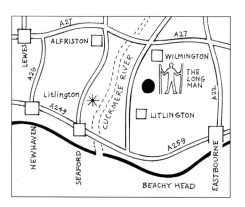

The enigmatic Long Man lies on the 20-degrees northern slope of 700ft (200m)-high Windover Hill near the small village of Wilmington and just north of Eastbourne. This carving is reputed to be the largest representation of a human figure in Europe. (The world's largest carving of a human figure is at Atacama in Chile. It is 125m high.)

Only guesses can be made on the meaning of the giant figure. It may go back beyond Roman times into the mists of pagan history. A chambered barrow is situated above the figure. A Romano-British-style carving of a centurion holding two standards may point to its time of origin, and with Roman tiles being found in the area, there is some support for dating it up to 2,000 years ago. Yet it is hard to believe that the image could have survived for so long.

The earliest drawing that we have today was made in 1717 by John Rowley, a surveyor, and shows a figure similar to the one that stands there today but with its legs astride and with more details in the face. Strangely, a later sketch of 1776 made by Sir William Burrell shows additions to the top of the two staves which turned them into a rake and a scythe. Has he now become a farm labourer? Other eighteenth-century reports speak of the staves as being clubs, spears or long bows. A myriad of other possibilities for the Long Man's creation are put forward by archaeologists, researchers and mystics alike who enthusiastically discuss legends and other theories concerning Celtic deities and ley lines.

A short distance below the figure stand the remains of a Benedictine priory which may have had some connection with it. That it was cut by monks during the Middle Ages as a guide for pilgrims and travellers is a most sustainable conjecture.

In 1874 the Long Man was rescued from obliteration by the Sussex Archaeological Society, assisted financially by the then Duke of Devonshire. The outline was stabilized by the laying down of 7,000 yellow bricks, which were later painted white. In 1889 a number of white glazed bricks were added when repairs were being made. Concrete blocks replaced the bricks in 1969.

In 1925 the ninth Duke gave the figure, the priory and two acres of land to the Sussex Archaeological Society which, together with the East Sussex County Council and the National Trust, keeps it in good condition. Scouring is done by the South Downs Conservation Board.

The Franklin, from *The Canterbury Tales* by Geoffrey Chaucer (c.1340–1400)

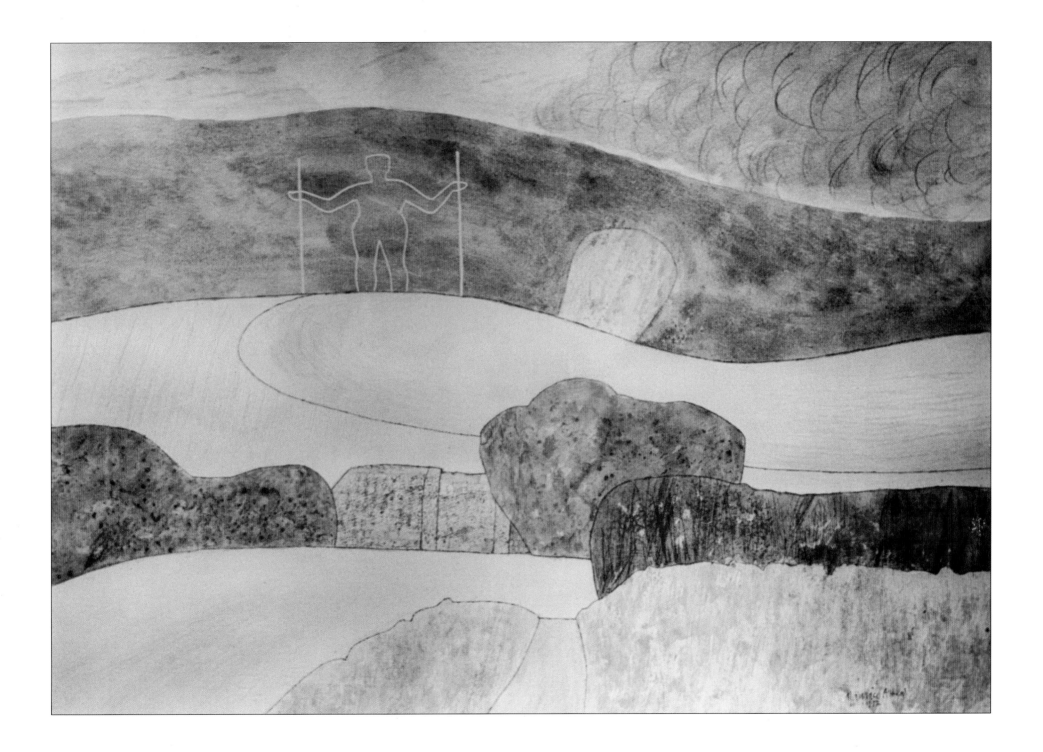

Westbury

Location: Wiltshire
Landranger Series No.183;
OS Grid ref: ST514895

Date: 1778
Dimensions: length 175ft (53m);
height 108ft (33m)

The Westbury, sometimes called the Bratton, white horse is, after Uffington, the oldest and best known of the hillside horses. It is cut on the steep 45-degrees slope of Bratton Downs between Bratton and Westbury in an area beloved by hang gliders. Looking out over the Vale of Pewsey it is clearly visible from the B3098 and from the rail lines between Bradford-on-Avon and Westbury stations. The horse is easy to reach from roads leading off the B3098.

A drawing made by Richard Gough, the editor of Camden's *Britannia*, in 1772 shows a small horse which faces in the opposite direction to the present one (see *White Horses and Other Hill Figures* by Morris Marples, 1981 edition). However, this may mean only that the engraver did not correct his drawing when transferring it to the printing plate.

History tells us that the Saxon King Alfred defeated Danish invaders in AD878 at Ethendune (possibly Edington, four miles east of Westbury) and it is conceivable that the earlier horse had been cut to commemorate this victory. Above the present horse is an Iron Age earthwork accepted as the Danish camp before the battle.

The stately steed of today was made in 1778 under the direction of a Mr Gee, Steward to Lord Abingdon, owner of the land. It was possibly cut on top of the much smaller and earlier horse. By the middle of the nineteenth century the new horse had deteriorated badly but it was rescued in 1853 and fully restored. Further reparation was carried out twenty years later when the carving was given a protective surround of stones. Drainage gratings were installed early in the twentieth century and concrete edgings replaced the stones in 1936. The chalk filling was replaced by concrete in the 1950s. The carving is now in the care of English Heritage and invariably kept in good condition.

It is possible that fairs and festivities took place during some of the earlier cleanings but these did not seem to be traditional and there have been no reports of any over the last hundred years. As was the case with most of the hill carvings, the Westbury horse was camouflaged during the Second World War.

The Coach (left) and *The Farmer* (right); both by Thomas Bewick (1753–1828)

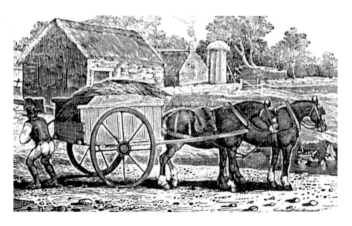

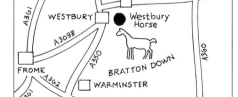

Cherhill

Location: Wiltshire
Landranger Series No.173;
OS Grid ref: SU045694

Date: 1780
Dimensions: length 130ft (40m);
height 140ft (43m)

The Cherhill White Horse stands on Marlborough Downs, just east of Calne, and can be seen clearly from the Marlborough to Calne road. It has been reported as visible from some 30 miles (50km) away.

There are two steep climbs to reach the carving from the A4 road, but the resultant views over the Wiltshire countryside are magnificent. Above the horse stand ancient earthworks called Oldbury Castle, while between the two runs a narrow track from which the visitor may view the horse.

It is not known whether an earlier horse stood on this spot, but it seems unlikely. Probably the horse that stands here today was cut under the stimulus of the Westbury horse, completed two years before. The originator was Dr Christopher Alsop of Calne (died 1816), called the 'Mad Doctor', possibly due to his mania for cutting the horse.

The carving appears to have been meticulously planned, especially with regard to the avoidance of perspective distortion. Using a megaphone from a distance of 1 mile (1.6km), Dr Alsop purportedly called directions for the placing of small flags by diggers working on the 45-degrees slope to mark the outline of the horse. Clean barrow loads of chalk were finally lowered from above the horse in small trucks and the body was filled in. The chalk was replaced with a mixture of chalk and concrete in 1935. According to early reports, the eye was originally composed of bottles that sparkled in the sunlight. These have long since vanished as souvenir hunting took its toll. The eye is now composed of rock and concrete, standing at a higher level than the rest of the animal. The horse seems always to have been kept in good condition, admired by early stage coach travellers journeying between London and Bristol.

The figure was camouflaged during the Second World War by gorse cuttings kept in place by netting which was removed in 1945, after which fresh chalk and concrete were packed in to restore it. Cherhill Council, helped by the National Trust, the British Trust for Conservation and other interested societies, scoured it thoroughly in 1994.

A nearby obelisk was erected in 1845 by the third Marquis of Lansdowne in memory of an ancestor, Sir William Petty. This has been restored recently by its present owner, the National Trust.

Cherhill village was once an important staging post for horse-drawn coaches plying between London and Bristol.

A Grey Hunter with a Groom and a Greyhound at Creswell Crags (detail), by George Stubbs (c. 1775) (© Tate London, 2001)

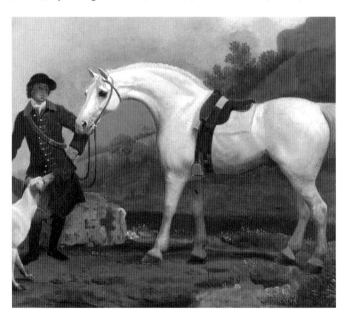

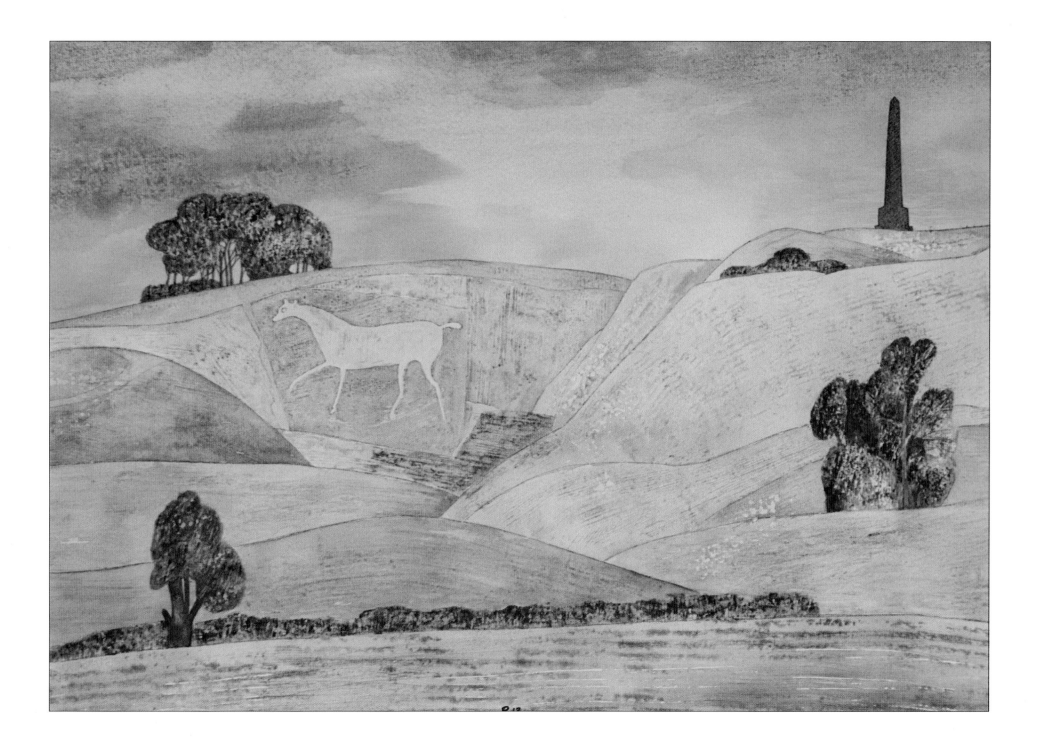

Marlborough

Location: Wiltshire
Landranger Series No.173;
OS Grid ref: SU179681

Date: 1804
Dimensions: length 62ft (19m);
height 48ft (14m)

On the fringe of the town built on a site where the legendary Merlin's tomb is reputed to have stood and where the name 'Merle's Barrow' later became Marlborough, may be found the smallest of the Wiltshire white horses. It sits perkily on Granham Hill on a gentle 35-degrees slope. It may be approached by branching off the A4 Bath road to Preshute village, from a footpath off the Pewsey road, called the Wansdyke path, or from the rear of Marlborough College. Consult the Marlborough Information Office town map.

The horse is naive and whimsical, a tribute to its young cutters. These were pupils from a Marlborough boys' school which stood in the town at the turn of the eighteenth century and was run by a Mr Greasley.

The figure was sketched by a senior student, William Canning, who pegged it out while others dug out the shape and packed it with chalk. There does not seem to have been any special reason for making it. Annual scouring became quite a tradition and the horse was always kept in good condition until the school closed on the death of Greasley in about 1830.

In 1838 the Revd Charles Plater conceived the idea of founding a school for the sons of clergymen of the established church. Work began on the school below the hill on which the white horse stood. A building on the site, the Castle Inn, had recently lost most of its trade as stagecoach travel gave way to rail. The inn was modified to accommodate 200 boys and masters and the new school opened in 1843. Five years later Marlborough College, as it was now known, had evolved into a major English public school under Royal Charter.

The hill carving had deteriorated to a perilous condition by 1873 when Capt Reed, a former pupil of Mr Greasley, arranged for its restoration, after which it was scoured intermittently over the following years.

In 1935 it was cleaned thoroughly by Boy Scouts in celebration of the Jubilee of George V and Queen Mary. It was again restored in 1945 after the Second World War and has, since then, been maintained faithfully by Marlborough College.

The horse is affectionately remembered in the lines of the College song:

> Ah, then we'll cry, thank God, my lads,
> The Kennet's running still,
> And see, the old white horse still pads
> Up there on Granham Hill.

Marlborough has much to offer visitors as a touring base. With the old churches of St Peter and St Mary at each end of the main wide street, Georgian buildings predominate. The River Kennet takes its name from Cunetio, a local settlement in Roman times.

Horse Racing (detail), by Samuel Hewitt (c. 1800) (print from *Orme's Collection of British Field Sports*, 1807)

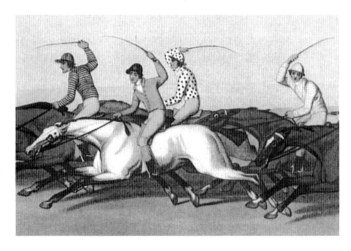

7

Osmington

Location: Dorset
Landranger Series No.194;
OS Grid ref: SY715833

Date: late eighteenth/early
nineteenth century
Dimensions: length 280ft (85m);
height 325ft (99m)

The Osmington Horse is one of the largest of the white horses and the only one with a rider. It sits a short distance north of Weymouth and can be seen clearly from the Weymouth to Wareham road and from the sea. There are long walks to the horse but the views from it are spectacular.

The design of the carving is stiff and formal, reflecting the style of paintings and public monuments at the time. It is generally accepted that the rider represents George III. The king was a regular visitor to Weymouth between 1789 and 1805, so the Osmington White Horse may have been commissioned by local dignitaries in his honour. It is possible that there was an earlier horse on the hill which was provided later with a royal rider.

Documents and newspaper reports of the time record that a well-known local architect, James Hamilton, planned the figure. It was cut on land owned by a local bookseller, Mr Wood, at the expense of John Rainier, brother to Admiral Lord Nelson, hero of Trafalgar in 1805 (see the web site www.yourhome4.com/arts/georgianwey/chapterfive.htm). Curiously the figure is riding away from Weymouth. Does this suggest the king was hurrying back to London? Another theory is that the rider represents the Duke of Wellington and was cut to commemorate his great victory at Waterloo in 1815. Around that time the chance of invasion by France was strong, so groups of soldiers and engineers were billeted along the south coast. It may be that one of these groups cut the horse.

It appears to have been well kept over the years. No doubt it was important for the growing seaside town to encourage visitors who would find the Osmington site an intriguing place to visit and an important attraction on sunny days.

There are no reports of the horse being camouflaged during the years 1939 to 1945, which is surprising given its location. Perhaps it was overgrown and in a poor state of preservation at the time. Today it is well cared for by the owner of the land and by English Heritage.

This is Thomas Hardy country with his cottage and memorabilia. There is also the Court room where the Tolpuddle martyrs were tried and sentenced to deportation for grouping together as a rudimentary trade union.

George III at a Review (detail), by Sir William Beechey (1753–1839) reproduced by gracious permission of HM The Queen. The Royal Collection © 2001 Her Majesty Queen Elizabeth II (The original painting, held in the Royal Collection at Windsor, was destroyed by fire in 1991)

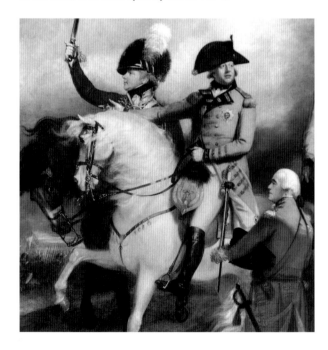

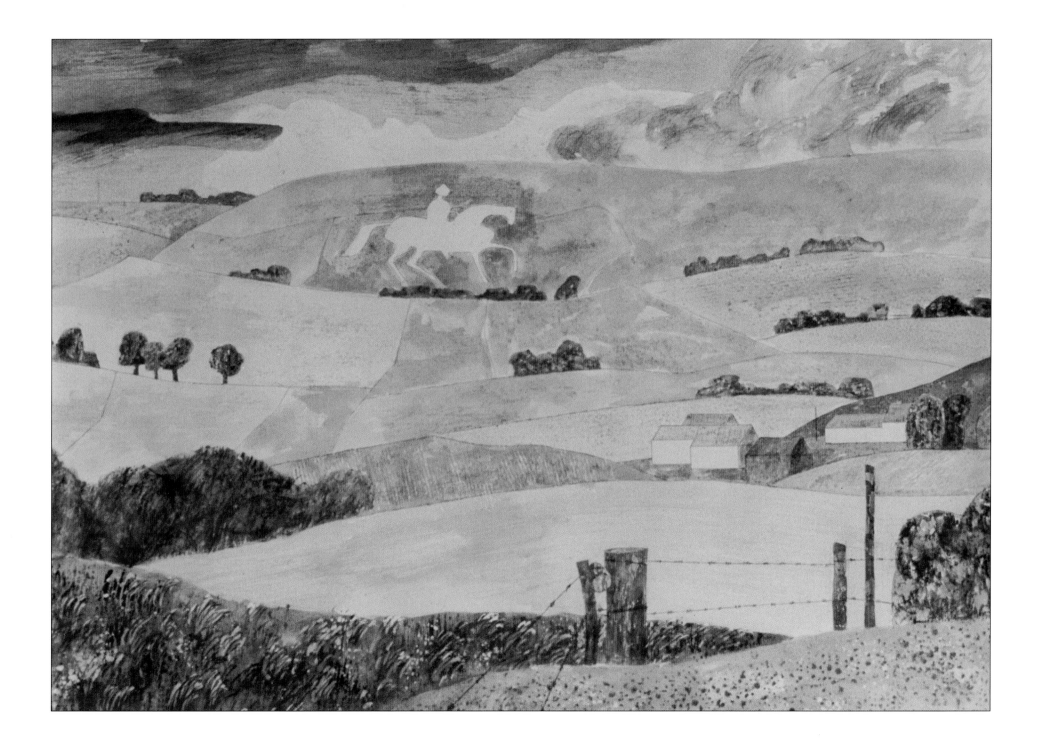

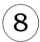

Alton Barnes

Location: Wiltshire
Landranger Series No.173;
OS Grid ref: SU109637

Date: 1812
Dimensions: length 160ft (48m);
height 180ft (55m)

The Alton Barnes Horse is close in style to the smaller Cherhill horse of 1780 which stands 5 miles (8km) away and was obviously familiar to the Alton Barnes cutters.

The horse stands on Old Adam Hill on a rise of 35 degrees and is at the approximate centre of the six major Wiltshire horses. There are unimpeded views of it from a bridge over the Kennet and Avon Canal near the village of Alton Barnes and from the canal siding itself. This is down a narrow lane turning off from a woodyard at the main road, leading to the Barge Inn on the canal bank. The horse can also be seen from other viewpoints including Old Sarum 22 miles (35km) away.

Close to the horse is a long barrow called Adam's Grave. This is quite prominent, with traces of a burial chamber at one end.

From notes made by the Revd E H M Sladen, possibly at the time of the horse's cutting (see the Revd W.C. Plenderleath's book, *On the White Horses of Wiltshire and Its Neighbourhood*, 1872), it was made to the orders of Robert Pile, the tenant of Manor Farm.

A local journeyman John Thorne, known in the area as Jack the Painter, was commissioned to plan and supervise the cutting of the horse for a fee of £20. He, in turn, used a John Harvey to dig out the turf and compact the chalk beneath it. Thorne, however, absconded with his money before the work was finished, leaving it to Pile to complete the horse. Thorne was later hanged, but for what crime we do not know.

Despite the premature departure of the designer, the horse is animated and bold. It has always been kept in fairly good order, paid for by public subscriptions which echo the local affection felt for it. In 1935 it was renovated by Boy Scouts and Girl Guides to celebrate the Jubilee of George V and Queen Mary.

There is a tiny, delightful museum in the village, crammed with old photographs and memorabilia. Information is available at the village shop.

Photograph from *The Illustrated Sporting and Dramatic News*, 13 May 1884

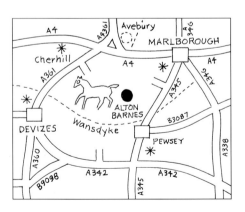

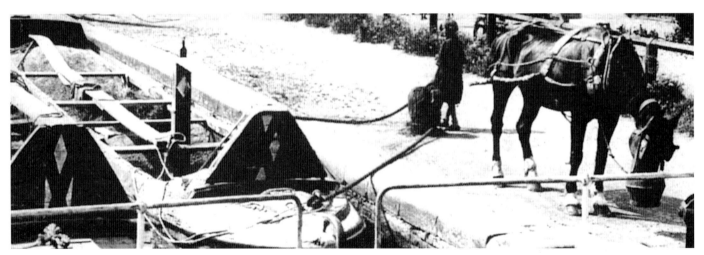

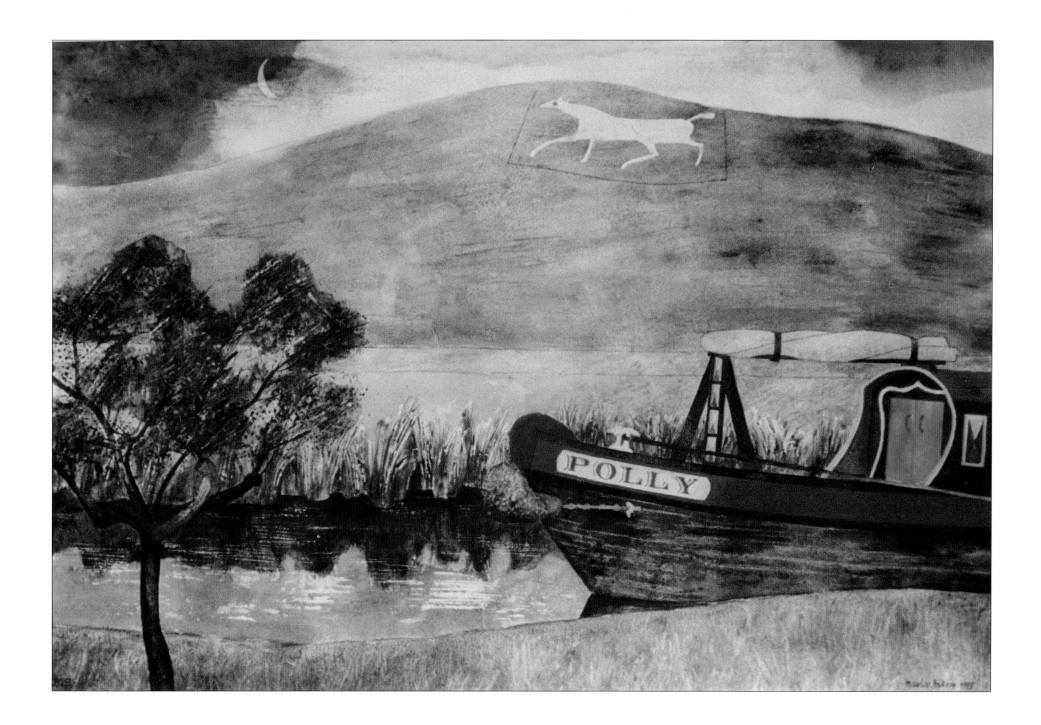

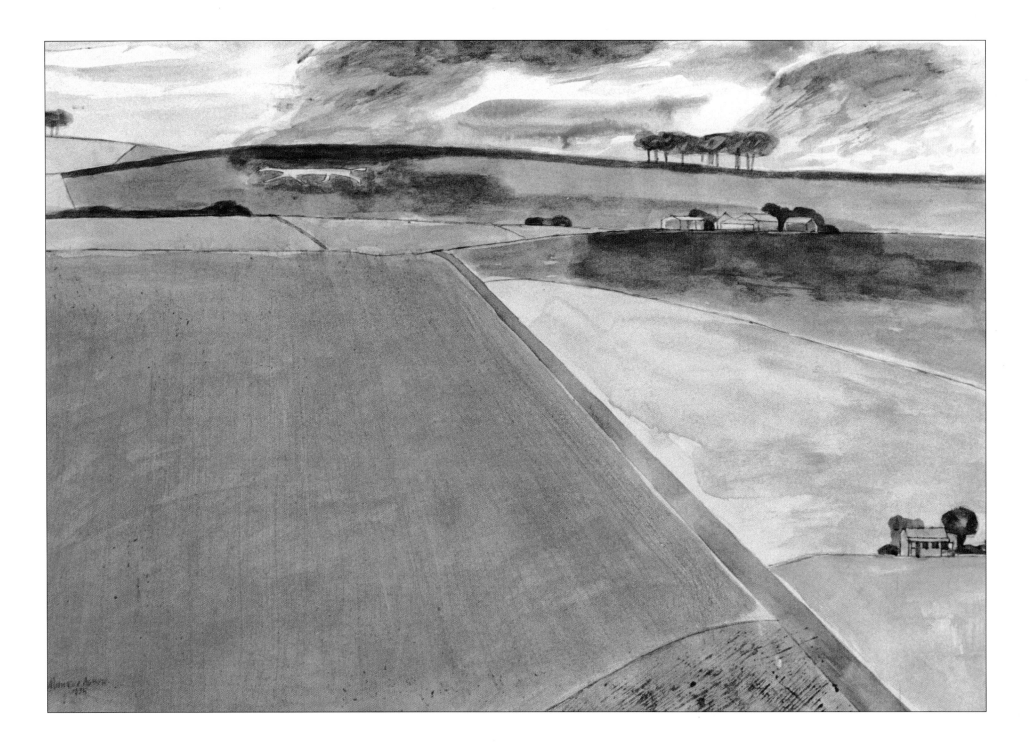

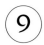

Hackpen

Location: Wiltshire
Landranger Series No.173;
OS Grid ref: SU125748

Date: 1838
Dimensions: length 90ft (27m);
height 80ft (24m)

The Hackpen Hill Horse, also called the Broad Hinton Horse after the nearest village, lies on a high but gentle slope on the fringes of the Marlborough Downs. It can be seen when driving up the hill on the B4041 Marlborough to Broad Hinton road. At the top, the road meets the Ridgeway track which crosses it. There is a car park and, if you are lucky, you may even find a travelling refreshment or ice-cream van parked there. A footpath leads down to the horse.

The cutting of the horse seems to have been instigated in 1838 by Henry Eatwell, who was parish clerk at the time, helped by a local publican Robert Witt, to celebrate the Coronation of Queen Victoria. There may have been an earlier horse on the hillside which had faded away, as a 1772 edition of *Britannia* shows a sketch of a horse which may have been this one (see *White Horses and Other Hill Figures* by Morris Marples, 1981 edition).

The problems of foreshortening in the horse had not been allowed for when the figure was originally planned and its attenuated body gives more the impression of a fox or a creeping cat than a sturdy horse.

By the beginning of the twenty-first century it had declined into a very poor condition since its last scouring in 1994. Fences surrounding it are broken down, allowing cows and horses to wander over it at will, so that it has acquired the romantic air of a gently fading creature of the past.

The Hackpen Horse is the closest hill carving to Avebury and the beginning of the Ridgeway Path. Avebury stone circle is generally acknowledged to be the most important Early Bronze Age site in Europe, dating from about 1800BC.

Fox Hunting: Full Cry (detail), by John Cordrey (1819) (from The Paul Mellon Collection, reproduced by permission of the Virginia Museum of Fine Arts, Richmond, VA)

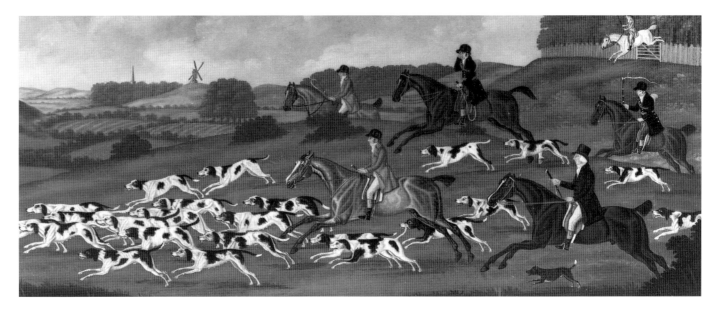

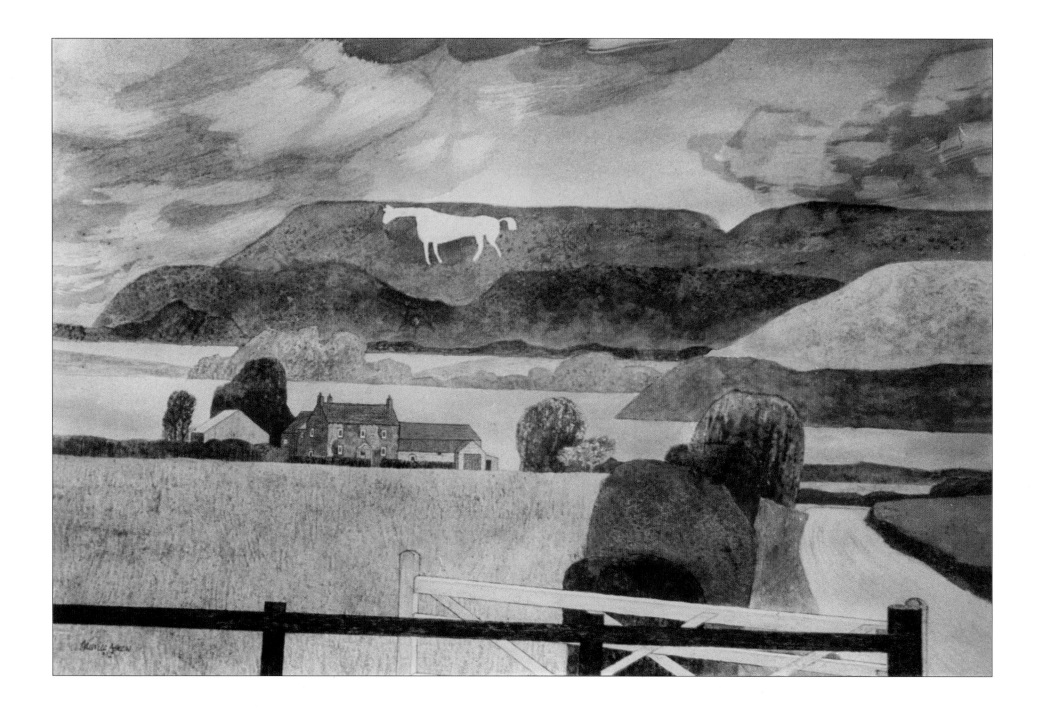

Kilburn

Location: Yorkshire
Landranger Series No.100;
OS Grid ref: SE813510

Date: 1857
Dimensions: length 300ft (90m);
height 228ft (70m)

One of the few horses not cut in chalk and not sited in the south of England, the Kilburn Horse lies on the Hambleton Hills near Kilburn village in Yorkshire. The land on which it lies belongs to the Ecclesiastical Commissioners.

Thomas Taylor, a wealthy merchant of Kilburn during the 1850s, discussed with his brother William, a storekeeper in London supplying Yorkshire hams and bacon, the possibility of cutting the image of a horse near their village. They were probably familiar with the white horses already cut on the South Downs. The brothers were joined in their venture by the Kilburn schoolteacher John Hodgson, who had experience in surveying. Together with a painter Harrison Weir, they planned the figure and directed the cutting. Then …

> … thirty-one men of Kilburn, who knew how to use the spade
> All went to work so heartily that soon the plot was bared …
> … In November 1857 the white horse first was seen
> With a brand new coat of lime which made him white and clean…

– as a local poet, Thomas Goodrick (1890–1929) wrote at the time (the words have been reproduced here by courtesy of the Goodrick's grandson, Fred Banks).

The hill slope is one of the steepest used for cutting figures but no serious problems seem to have arisen during the work. After the deaths of the Taylor brothers the horse began to deteriorate in spite of sporadic cleaning by local families. It was not until 1925 that a wider public interest was rekindled through the involvement of the *Yorkshire Evening Post* which launched an appeal fund to rescue the horse.

In 1973 the Kilburn White Horse Association was formed as a registered charity. Help continues today from the *Evening Post*, the Leeds and Holbeck Building Society, local farmers' clubs and other interested bodies.

It is now possible for the horse to be 'groomed' quite regularly. Unlike the chalk base of the southern Downs, the subsoil here is clay and sandstone so that it is essential that the horse be whitened at frequent intervals. Several agents have been tried, but the original one, limewash, still tends to be the best cover for the surface.

There are good car parks above and below the horse. Concrete steps link the two but it is a long haul between them. The hillside is too steep to be able to stand on the horse.

A Farrier's Shop (also called *The Farrier's Forge*) (detail), by George Morland (1793) (© Manchester City Art Galleries)

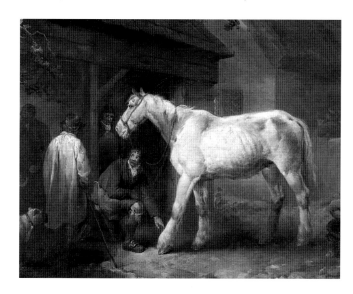

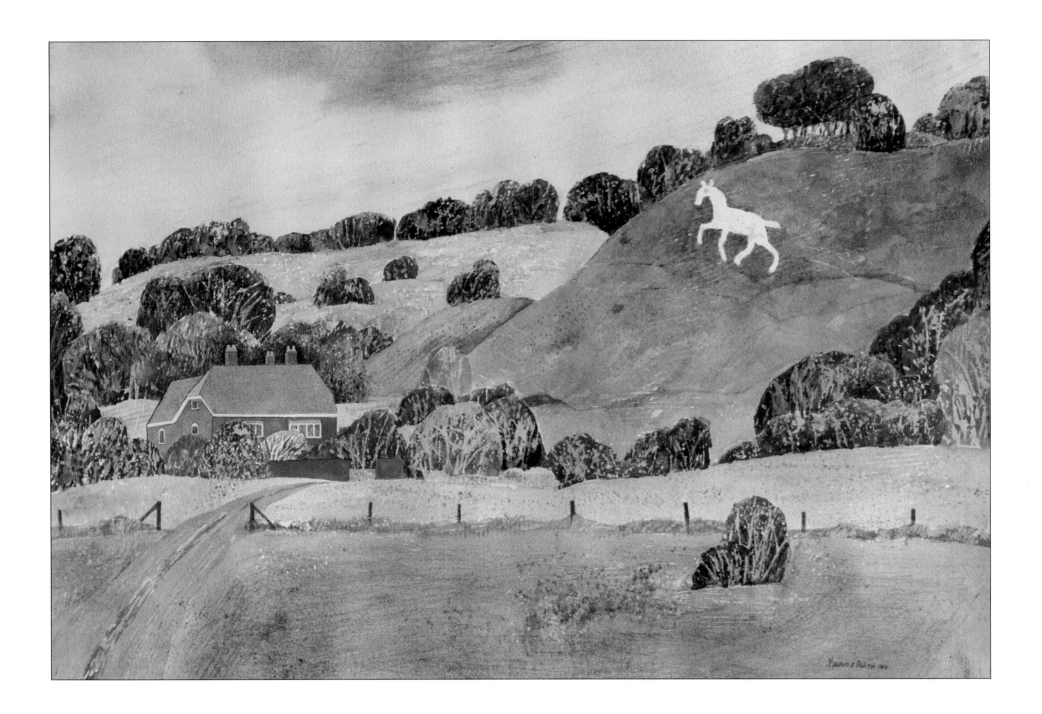

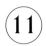

Broad Town

Location: Wiltshire
Landranger Series No.173;
OS Grid ref: SU100784

Date: 1864
Dimensions: length 78ft (24m);
height 75ft (22m)

Although the Broad Town Horse stands on a reasonable incline of 45 degrees, from many directions it is obscured by trees and hedges. Glimpses may be had of it from the Marlborough to Wootton Bassett road and from the Swindon to Bristol railway line. But the best view may be obtained from Chapel Lane, which turns off the main road through Broad Town village. It is on private land and the hill should not be climbed. Neither is it possible to approach the horse from the top of the hill.

W C Plenderleath, in 1864 (see *White Horses and Other Hill Figures*, by Morris Marples, 1981 edition) believed that the figure had been cut by William Simmonds of Littleton Farm on whose land it lay. This was disputed by a curator from the Imperial War Museum in London. In a letter to the *Morning Post* in 1919 he described how, in 1863, he visited a horse at this location with a friend. They cleaned up the carving that he considered had been there for at least fifty years before. Confusion now creeps in, since it may have been the Hackpen Horse to which they had gone, or perhaps Simmonds did not cut a new horse in 1864 but only renovated one already standing on his land. Whoever made it produced a figure that is vigorous in style, with a lively trotting stance. In 1991 the horse was completely renovated by the local community through the activities of the newly formed White Horse Restoration Society. Grants from the Wiltshire Community Trust and the people of the village supported the work. Enthusiastic volunteers now maintain the horse on a regular basis.

Interior of Stable (detail) by Thomas Rowlandson (1756–1827). Yale Center for British Art, Paul Mellon Collection, New Haven, USA. Reproduced by kind permission

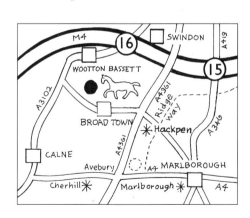

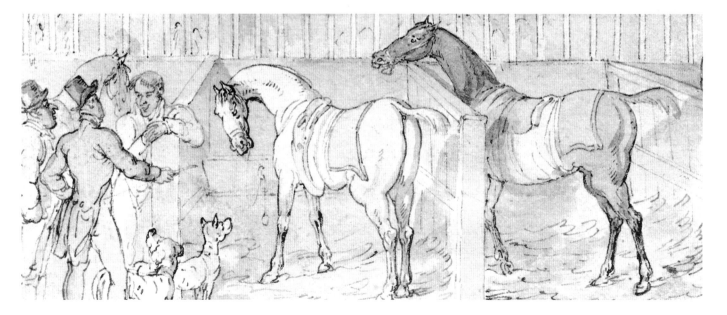

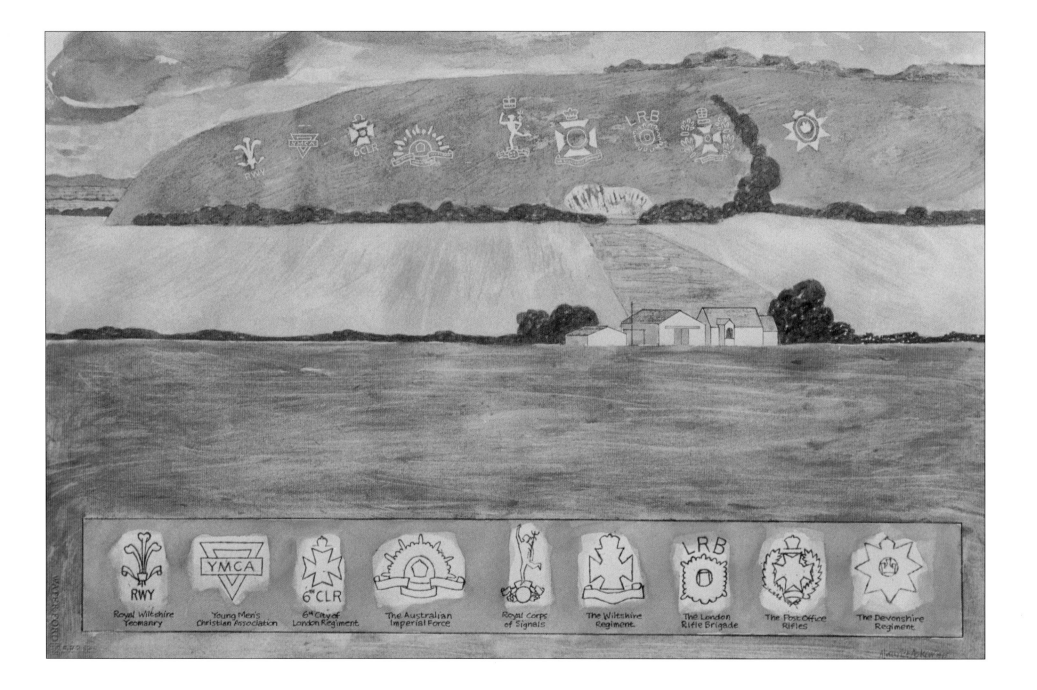

Royal Wiltshire Yeomanry

Young Men's Christian Association

6th City of London Regiment

The Australian Imperial Force

Royal Corps of Signals

The Wiltshire Regiment

The London Rifle Brigade

The Post Office Rifles

The Devonshire Regiment

Fovant Badges

Location: Wiltshire
Landranger Series No.184;
OS Grid ref: SU0199439

Date: 1916–18

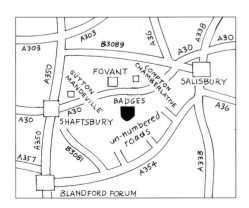

A long stretch of smooth, fairly steep hillside runs parallel to the Salisbury to Shaftsbury A30 road. On this the regimental badges, facing towards Fovant, may be clearly seen. There are lay-bys on the road from which the images can be viewed. At one there is a clear and precise information board describing the badges.

Just before the outbreak of war in 1914 a large area of land was commandeered at Fovant as a training and transit camp for newly enlisted troops. It was completely self-contained with all the facilities of a small town, including a hospital, a cinema and a railway depot. The first regiment to emulate the nearby white horse figures of Wiltshire by cutting their company badge was the London Rifle Brigade (LRB) in 1916. Soldiers from the Brigade had come back from the Western Front to convalesce from minor wounds before returning to the trenches of France. Other regiments followed the LRB example and began cutting their own badges, the soldiers working from break of day until the adjacent rifle ranges came into use after breakfast.

The turf was dug away and fresh chalk from a nearby quarry packed in. The badges created in this manner have lasted well over the years. Others, made by simply piling chalk on top of the grass, have long since been lost. By the end of the war twenty badges could be seen on the hillside.

Following the Second World War, during which the badges had been camouflaged, the Fovant Home Guard Old Comrades Association was approached by some of the London regiments to consider the restoration of the carvings. Between 1949 and 1954 nine of the original badges were restored and three new ones were added close by. At Compton Chamberlayne there is a carved map of Australia and at Sutton Mandeville are the badges of the 7th City of London Regiment and the Royal Warwickshire Regiment. Since 1955 memorial services have been held on the first Sunday of each July at Fovant.

The Fovant Badges Society was established in 1963, dedicated to the preservation of these carvings as a memorial to the men who were at the camp during the First World War and to an important event in British history. Sadly though, unless more funds rapidly become available to the Society, many if not all of the badges will finally disappear.

Inspection by George V during the First World War, showing Camp 13 with badges on the hillside, c. 1916, by Sydney R Jones

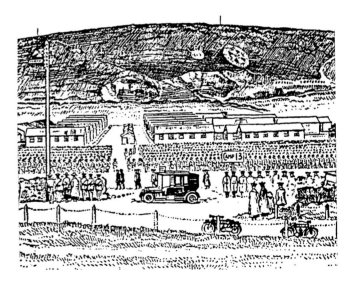

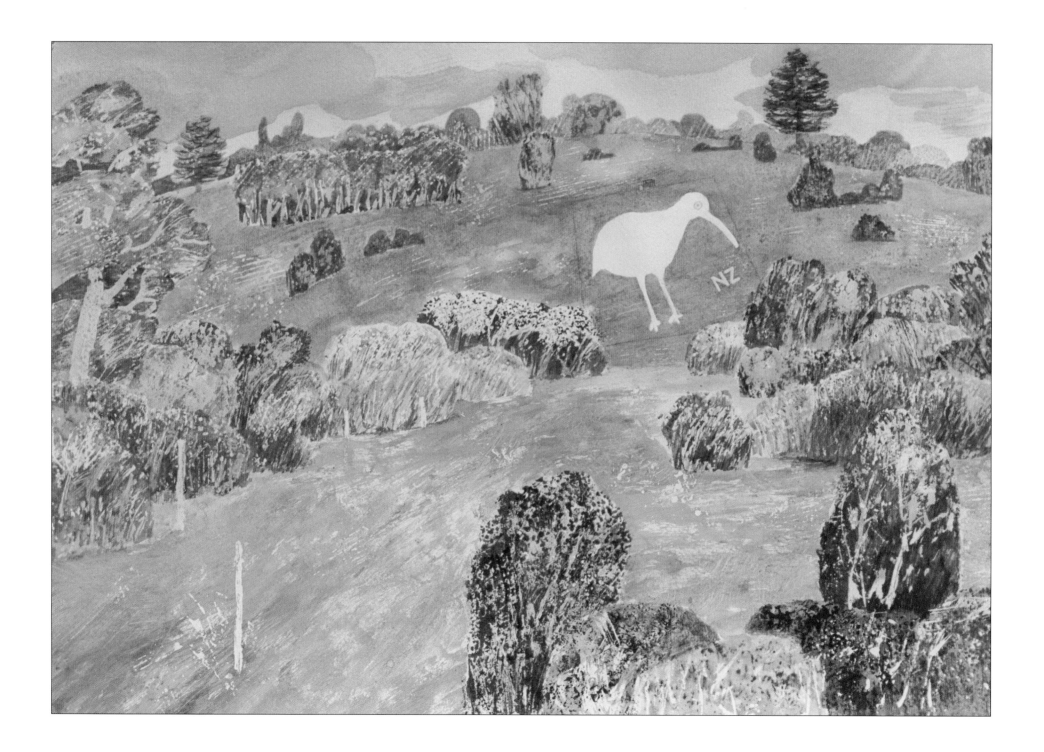

Bulford Kiwi

Location: Wiltshire
Landranger Series No.184;
OS Grid ref: SU201440

Date: 1919
Dimensions: height 420ft (128m);
width 400ft (120m)

At the outbreak of the First World War construction began on a hutted camp near Bulford village, just north of Salisbury. This complex, later known as Sling Camp, was to house the British section of the New Zealand Expeditionary Force. A short time later the Canadian Expeditionary Force occupied the camp and continued with the building work. New Zealand troops returned to full occupancy in 1916, when its name was changed to ANZAC Camp. It became the main camp in Britain for New Zealand troops. At the end of the war over 4,000 soldiers were at the camp awaiting repatriation.

To provide some relief from the tedium of parades and drills, Lt Col A G Mackenzie proposed that an image of New Zealand's national icon, the kiwi, be cut in the chalk of Beacon Hill which rises at a shallow incline behind the camp. A drawing instructor, Sgt Maj Percy C Blenkarne of the New Zealand Army Education Corps, produced a sketch of the bird for reference. The digging proceeded until the carving that we see today was complete and covered an area the size of a Rugby field. The kiwi is not easy to see from a distance, being partially screened by trees and bushes. It is best approached by an unmarked road and track off the A8028 and then on foot across scrubby land.

For some years the Kiwi Polish Company funded work to keep the kiwi in good repair but in 1968 the New Zealand High Commission undertook the cost of its upkeep. In 1979 249 Signal Squadron, which was now in residence at the camp, took over the care of the bird, completely restoring it and trucking in fresh chalk from a nearby quarry.

New Zealand, recognizing the great importance of the carved figure and the cost and effort being put into its preservation, presented a carved kiwi trophy to the Squadron in 1984 through the British New Zealand Society. This trophy is awarded annually to the soldier who achieves the best performance in a special biathlon. The finishing post is at the head of the kiwi. The day is celebrated by the attendance at the camp of representatives from the New Zealand Defence Staff and the High Commission, and it concludes with a wreath-laying ceremony at either Tidworth Military Cemetery or at St Mary's parish church at Codford. Both cemeteries contain the graves of New Zealand and Australian war dead.

In 1993 connection was re-established between 249 Signal Squadron and No.3 Signal Squadron in Christchurch, New Zealand.

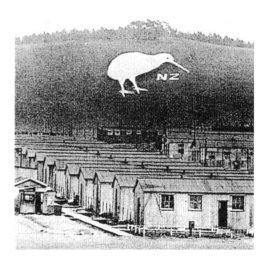

Photograph of Bulford Camp, 1917

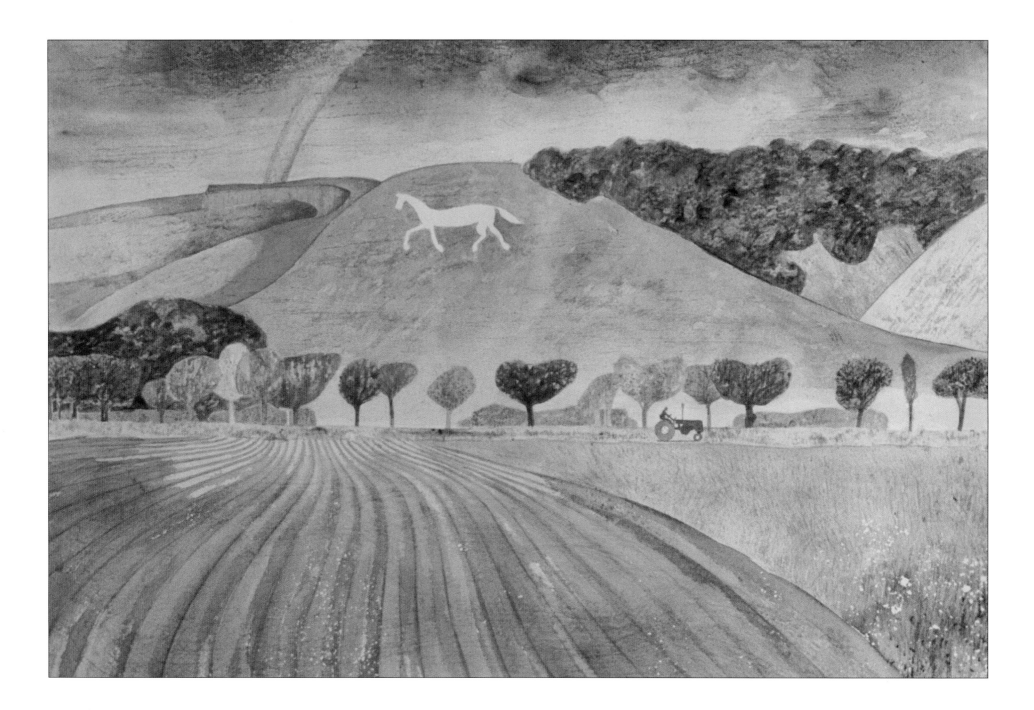

Litlington

Location: Sussex
Landranger Series No.199;
OS Grid ref: TQ512008

Date: 1924
Dimensions: length 90ft (27m);
height 80ft (24m)

Between Newhaven and Eastbourne, near Seaford, a small horse stands on Hindover Hill near Litlington village. It is quite prominent from the South Downs Way, local lanes, Beachy Head and the sea. It stands on Frog Firle Farm land. An earlier horse once stood there, cut by James Pagden and his family in 1838 to commemorate the coronation of Queen Victoria, but this had faded away by the 1920s.

The present horse, in good condition, was cut during one night in 1924 by three friends John Ade, Eric Hobbis and a Mr Bovis. It does not seem to have had links with any special event that was happening at the time and was made, one assumes, just to place the names of its creators in the history books.

The carving was camouflaged during the Second World War but it was later restored under directions from the Air Ministry. In a scouring during the 1980s the formal standing legs were abandoned, giving way to prancing ones, partly to obviate the slipping away of chalk rubble at the bottom of the image and partly, no doubt, also to liven it up somewhat. In 1991 the carving was acquired by the National Trust and it was given a good scouring in 1993.

The top of the horse may be approached from a small car park off the road which runs above it. There is a narrow walk track through scrub and bushes to a viewing area just above the horse. Scrambling down to the horse itself poses some difficulty, but if the visitor does reach it he will find it safely guarded with a barbed wire fence.

Litlington village church, dating back to Norman times, has some fine stained glass and a large font well over 500 years old.

A Galloping Horse Enigma

In 1872 in the United States the Englishman Eadweard Muybridge investigated the question of whether a galloping horse has, at certain moments, all four of its legs simultaneously free from contact with the ground. With primitive photographic equipment he set up a line of cameras along a race track. As a horse galloped past, the cameras were triggered by trip wires to produce a sequence of images showing the phases of the horse's motion. Muybridge proved that the legs of a galloping horse left the ground simultaneously only when bunched beneath the horse, not when outstretched, as had previously been portrayed (see pp.14 and 21). The plates below are reproduced in their actual size from a sequence of sixteen published originally by Muybridge in *The Horse in Motion*, in 1878.

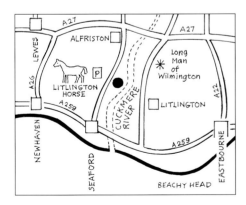

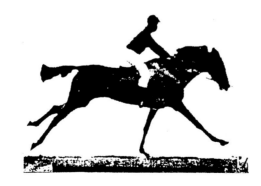

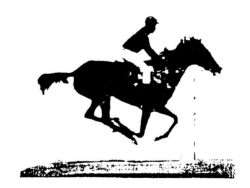

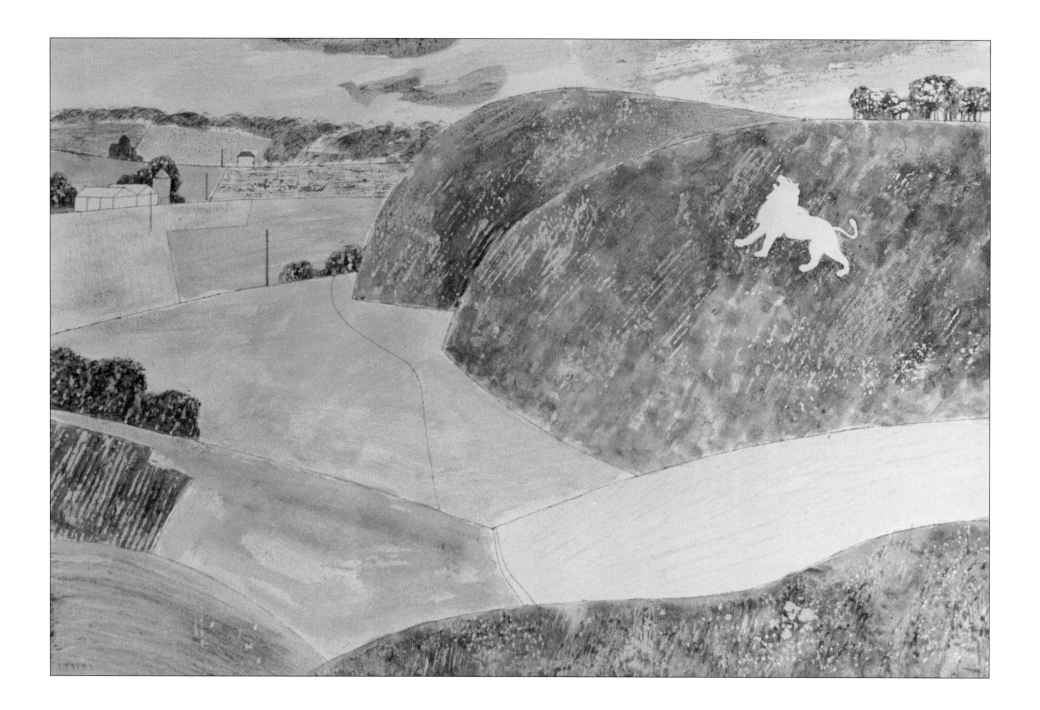

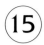

Whipsnade Lion

Location: Bedfordshire
Landranger Series No.166;
OS Grid ref: TL995176

Date: 1935
Dimensions: length 483ft (147m);
height 200ft (60m)

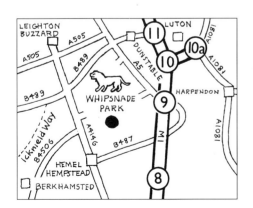

The Whipsnade Lion lies 34 miles (54km) from London on Dunstable Downs and just below the wild animal park of the same name. The park was opened in 1931 by the Zoological Society of London as an extension of the Regent's Park Zoo. Covering almost 600 acres (242 hectares) of chalk downs, woodlands and meadowlands, it was the first open zoo to be established in Europe. As well as being famed as a world-renowned park, it is a haven for many species of fauna and flora.

The carved lion, which stands on a hill dropping steeply to the valley at its feet, is clearly visible from long distances. The end of the Ridgeway track is 2 miles (3km) away at Ivinghoe Beacon from which there is a fine view across the valley to the lion. It can be seen intermittently from many roads in the area, but probably the best view is had by air travellers using Luton Airport.

The figure was designed by R B Brook-Greaves and cutting started in 1932. Its progress was constantly monitored from Ivinghoe Beacon. The brief was to give it a fairly benign image and to suggest a slow walking pace which visitors might emulate as they themselves roamed through the park. It is quite realistic with no attempt to stylize it or to give it a modernistic or heraldic impact. Concrete edgings hold back encroaching grass from the carving while several methods of washing and whitening are employed to keep it in pristine condition. It undergoes reparation approximately every five years.

During the Second World War the lion was camouflaged with netting, turf and green paint, then restored by the Air Ministry in 1945. In 1981, on the fiftieth anniversary of the park's creation, the lion was illuminated for the first time with 750 40W bulbs. Ten years later this system was dismantled and replaced by hundreds of tiny bulbs encased in weather- and vandal-proof plastic tubing. These were first used in 1996 on the occasion of the park's sixty-fifth birthday. In September 2000 the lighting system was switched on for a public appeal to raise money to build a new home for endangered Asian lions.

The Heraldic Lion

The lion, as an English heraldic symbol, was first used on a shield presented by Henry I to Geoffrey Plantagenet in 1127 on his marriage to Henry's daughter Matilda. Geoffrey was Duke of Anjou and his name was anglicized from his nickname *Plante Genista*, referring to the sprigs of yellow broom that he wore as a crest in his helmet.

Geoffrey Plantagenet: portrait in enamel, Le Mans Cathedral

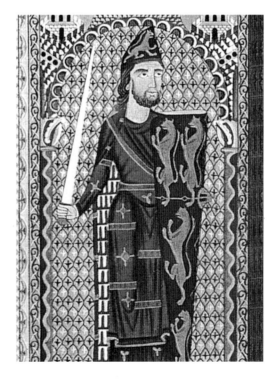

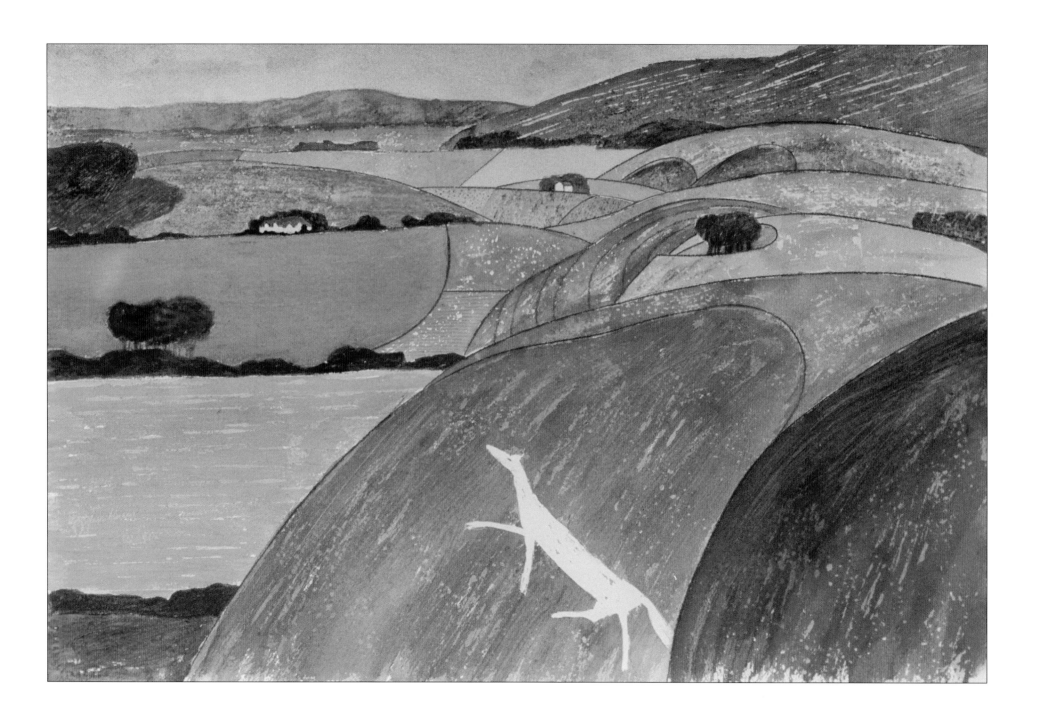

Pewsey

Location: : Wiltshire
Landranger Series No.173;
OS Grid ref: SU168581

Date: 1937
Dimensions: length 66ft (20m);
height 45ft (14m)

The Pewsey White Horse stands on a steep hillside between Marlborough and Amesbury; there are good views of it from the A345. It can be reached by a short walk from the minor road between Pewsey and Everleigh. There are also tracks leading to the top of the figure.

A horse had existed in 1785 near this site, cut by Robert Pile (who later cut the Alton Barnes Horse), but this first horse gradually reverted to grass. In 1937 a new horse was designed and cut a short distance from the almost completely vanished old one. The new horse was made to commemorate the coronation of George VI and Queen Elizabeth. It was designed by the late George Marples of Sway, Hampshire, a major authority on hill figures who spent many years travelling throughout Britain, measuring and gathering information on the figures. He had been familiar with the earlier Pewsey Horse. Later, his son Morris Marples collated his father's works and in 1949 published *White Horses and Other Hill Figures* as the most extensive work on the subject at that time.

The present Pewsey Horse is particularly well-proportioned and has a carefree trotting stance. It was cut by the Pewsey Fire Brigade, camouflaged during the Second World War and restored by the Air Ministry in 1945. The figure stands on private land but has always been well maintained by local groups. It was scoured in 1985 by Pewsey firemen and young people on a Youth Training Scheme and then again in 1998 when it was fenced to protect it from wandering animals. Members of a 6X Club, named after a local ale, now keep it in trim.

Pewsey is a pleasant village with connections with King Alfred who owned land in the area. There is a Heritage Centre in the High Street with extensive collections of old farm machinery, local artefacts and photographs, but with only limited opening hours which intending visitors need to check carefully. The church of St John the Baptist has Saxon beginnings and a fifteenth-century tower.

The farm horse gives way to the tractor in the twentieth century (photographs reproduced by courtesy of the Rural History Centre, University of Reading)

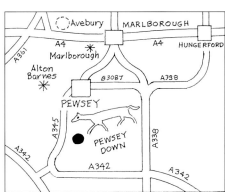

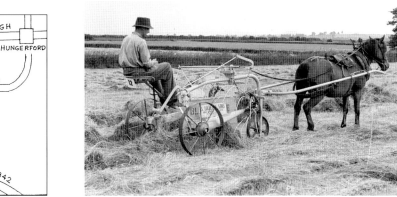

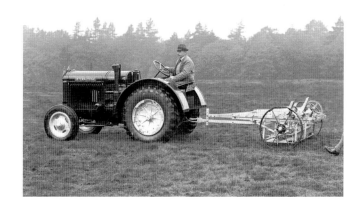

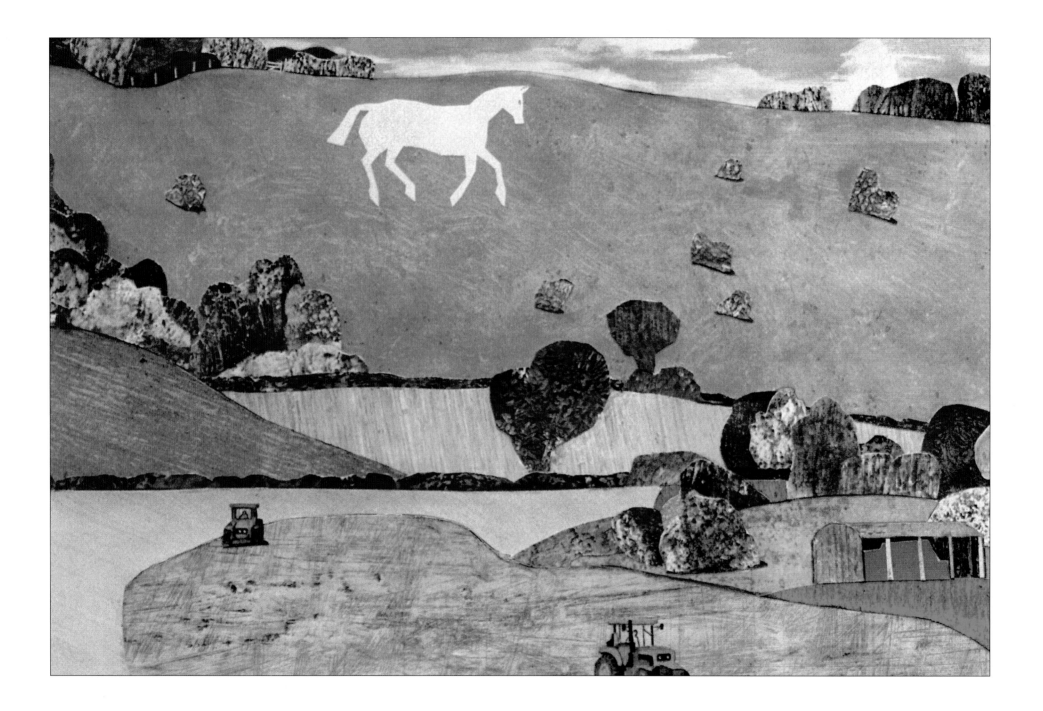

Devizes

Location: Wiltshire
Landranger Series No.173;
OS Grid ref: SU005627

Date: 2000
Dimensions: length 150ft (46m);
height 148ft (45m)

In 1998 a group of residents of Devizes formed a committee led by Peter Greed, Sarah Padwick and John Markwell and strongly supported by Wiltshire Tourism. Their aim was to celebrate the millennium by cutting a new white horse near the town. Peter Greed, when a senior pupil at Devizes Grammar School in the 1950s, had made a detailed plan of an earlier horse which had been cut by apprentice shoemakers in 1845 but did not seem to have marked any special event. Called Snob's Horse, after the local dialect word for apprentice shoemakers, little remained of it by the middle of the twentieth century.

The land on which it had been cut marked an important battle during the Civil War where Cromwell's troops had been defeated by Royalist forces. The area has since been declared one of Special Scientific Interest and so was not available for a new horse to be cut there. Chris Combe, a local farmer, offered land which he farmed on nearby Roundway Hill as an alternative site and planning permission was granted to use it. In 1998 Sarah Padwick had suggested that an image in the form of a crop circle might be used, but later discussions accepted that the detailed plan made in 1954 by Peter Greed should form the basis of the design for a horse. This was now to face right instead of left, as the original Snob's Horse had done.

An appeal went out to the public to support the cutting financially through invitations for subscribers to become 'Cavaliers of the Devizes Millennium White Horse'. The marking out and the cutting of the outline by hand took place during August and September 1999. The mechanical excavation and the final chalk infill were carried out by Pearce Civil Engineering at the end of September. Major participating groups included Army Cadets, the Fire Brigade, Girls' Brigade, Scout

groups and Sarsen Housing Association. Many local schools were involved, as also were Wiltshire Tourism and the Crown Commissioners who own the land on which the horse stands. The horse was officially declared 'open' and dedicated on 31 December 1999. Sarsen stones mark the eye and nostril. A time capsule was buried, perhaps to be opened in 200 years' time.

To reach the horse drive to Roundway Industrial Estate and then to Roundway Hill. At the top is Bank Field on which the horse is cut. There is a gate that leads directly to the figure.

The lovely market town of Devizes possibly derives its name from the Latin *divisas* meaning 'at the meeting of' a number of manor estates. The daughter of Henry I, the so-called Empress Matilda, claimed the throne for a short time after her father's death. During this time, in 1141, she granted a Royal Charter to the town. Devizes is a perfect base for exploring the Wiltshire area including many of the other hill figures of England.

Three people on a horse: the Devizes Millennium White Horse from the air, photographed from the Wiltshire Police Force helicopter in 2000

Codford Badge

The ANZAC or Rising Sun badge was cut by Australian troops, possibly those on punishment fatigues at the time, who were stationed in the area during the First World War. It is 175ft (53m) by 150ft (46m). At Codford St Mary are the graves of sixty-six New Zealand and thirty-one Australian troops.

Whiteleaf Cross

A huge image cut on the Chiltern Hills and currently under the care of Buckinghamshire County Council. The cross is 250ft (76m) in height. Its age is uncertain as the earliest printed report is a manuscript of 1742. It seems to suggest religious origins, but may have been a signpost.

Bledlow Cross

A 30ft (9m)-Greek cross cut near Chinnor in Buckinghamshire. Its age and origins may only be guessed at as the earliest recorded report of it is in *The Gentleman's Magazine* in 1827. It may be as early as the fourteenth or as late as the eighteenth century.

Wye Crown

The figure, 180ft (55m) by 170ft (52m), stands near Wye College in Kent. A D Hall, the first principal of the College, suggested a crown which was designed by T J Young, a lecturer in agriculture. Its cutting was to celebrate the Coronation of Edward VII in 1902.

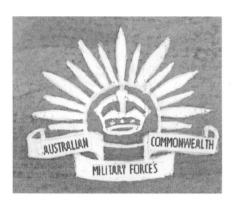

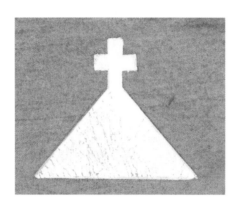

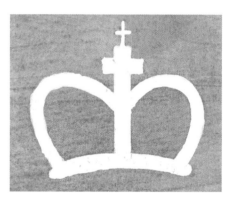

Map of Australia

At Compton Chamberlayne.

7th Battalion City of London Regiment

At Sutton Mandeville.

Royal Warwickshire Regiment

Also at Sutton Mandeville.

Horse on the Hackpen White Horse

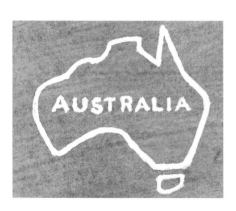

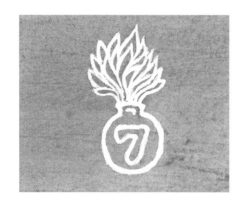

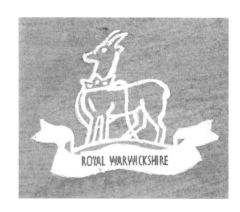

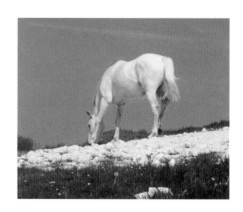

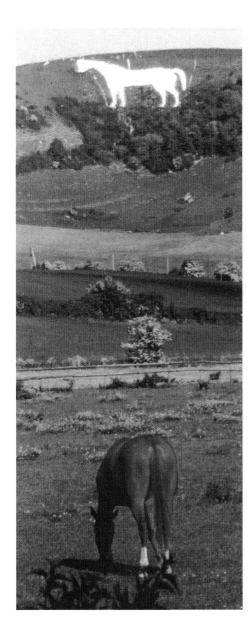

Horses at Westbury

Bibliography

Bergamar, Kate, *Discovering Hill Figures* (Shire Publications, 1997)

Goodman, Kent, *Chalk Figures of Wessex* (Wessex Books, 1998)

Hughes, Thomas, *The Scouring of the White Horse: A Novel* (Macmillan, 1859)

Marples, Morris, *White Horses and Other Hill Figures* (Sutton Publishing, 1981 edn)

Newman, Paul, *The Lost Gods of Albion* (Sutton Publishing, 1997)

Thorpe, John, *Kilburn and Its Horse* (Kilburn White Horse Association, 1995)

Wilcock, John, *A Guide to Occult Britain* (Sidgwick & Jackson, 1976)

Wiltshire Tourism, *Wiltshire's White Horse Trail: A Ninety Mile Long-Distance Walking Route* (1999)

Web Sites

There are a growing number of web sites available giving both general and specific information on hill carvings. Important ones are:

www2.prestel.co.uk sites about individual figures

www2.prestel.co.uk/hows/personal/hillfigs/ is a good introduction

Also look at:

www.i-way.co.uk/~who/horses.html

www.stonehenge.co.uk/white_horses/whitch_home.htm

www.yourguide.org.uk/whitehorse/index.htm

www.web.inter.nl.net/users/animal/chronoph/muybridge/index/htm

Acknowledgements

My thanks go to Michael J A Ashbury, Fred Banks, Claudia Calam, Michael J Duckenfield, Gillian Gouge, Angela Graham, Peter T Greed, Peter Holliday, Mark Hows, John Markwell, Ruth James, Bob Mills, Roy Nuttall, Sarah Padwick, Howell Perkins, John M Ray, Jane Sharland, Anne Sheppard, Rosemary Wyeth, and to Susan Askew for editorial assistance.

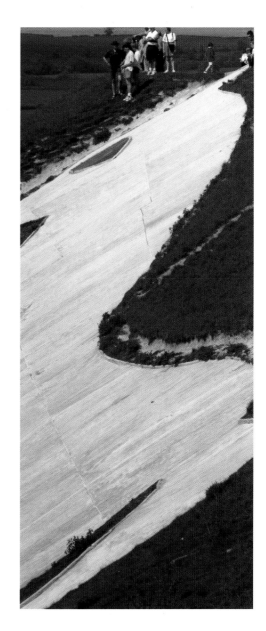

People at Westbury

First published in 2002 by
The Crowood Press Ltd
Ramsbury, Marlborough
Wiltshire SN8 2HR

British Library Cataloguing-in-Publication Data
A catalogue record for this book is available from the British Library.

ISBN 1 86126 480 1

Typeset by Annette Findlay

Printed and bound in China for Midas UK Ltd